THE ANIMALS ARE LEAVING US

OF RELATED INTEREST

THE ANIMALS ARE LEAVING US

WORDS BY MARTIN ROWE
IMAGES BY JO-ANNE MCARTHUR

Lantern Publishing & Media • Brooklyn, New York

2021
Lantern Publishing & Media
128 Second Place
Brooklyn, NY 11231
www.lanternpm.com

Printed in the United States of America

Library of Congress Cataloging-in-Publication Data

Names: Rowe, Martin, author. | McArthur, Jo-Anne, photographer.
Title: The animals are leaving us / words by Martin Rowe ; images by Jo-Anne McArthur.
Description: Brooklyn, New York : Lantern Publishing & Media, 2021.
Identifiers: LCCN 2021010196 (print) | LCCN 2021010197 (ebook) | ISBN 9781590566459 (hardcover) | ISBN 9781590566466 (epub)
Subjects: LCSH: Animal welfare—Poetry. | LCGFT: Poetry.
Classification: LCC PS3618.O873 A84 2021 (print) | LCC PS3618.O873 (ebook) |DDC 811/.6—dc23
LC record available at https://lccn.loc.gov/2021010196
LC ebook record available at https://lccn.loc.gov/2021010197

CONTENTS

INTRODUCTION

Martin Rowe

Early in 2019, the Canadian photojournalist Jo-Anne McArthur of We Animals Media sent me a photo she'd taken during a recent visit she'd made to a Thai slaughterhouse. I was very familiar with Jo-Anne's images. I published *We Animals* and *Captive*—her first two volumes of photographs of animals in the human environment—at Lantern Books in 2013 and 2016 respectively. I consulted with her on a third volume, *Hidden: Animals in the Anthropocene*, which Lantern's new iteration, Lantern Publishing & Media, started distribution of in 2020. Jo-Anne's photo of Kunik the polar bear in the Toronto Zoo in 2006 had stirred my imagination so strongly that I wrote *The Polar Bear in the Zoo: A Speculation*, which I published at Lantern in 2013.

The 2019 picture had a galvanizing effect on me—despite, or perhaps because of, its subject matter. It shows three men standing around a pig kneeling on a blood- and soap-drenched floor. Another man holds a wooden club in his hands, poised to bring it down on the pig's head.

As "The Animals Are Leaving Us" observes, the stunning, killing, and evisceration of a nonhuman animal for our consumption or utilization of their body parts happen millions of times each day around the world. Sometimes, that process is more mechanized, and occurs more quickly and perhaps with less pain; at other times, it is attenuated, blatant, and agonizing. Either way, a life is taken, bloodily and violently. That it happens so often and at such a scale doesn't make it any more necessary or justifiable.

In her decade and a half as a chronicler of the lives and deaths of animals in the human environment, Jo-Anne has captured hundreds of moments like this one. Some of them are featured in this book, and you can see many others in the We Animals archive at WeAnimalsMedia.org. Her work displays precise moments of willed or accidental cruelty. Her lens pokes into places where animals stand alone, seemingly forgotten; her camera turns on us, as we surround the animals and gesticulate, laugh, or point our own lenses at them. Jo-Anne's animals may be the objects of our intense gaze or mere props in a "scene," but they're usually confined, whether held in actual cages, shackled, kept isolated in compounds,

stacked in crates, or laid among a mass of sickened, desperate bodies in an anonymous shed.

Unlike photographers of "charismatic megafauna" (whether in the wild or in the studio), Jo-Anne doesn't shy away from showing how animals' lives are traduced, their options narrowed, and their behaviors curtailed by *we* animals. Her lens centers on our twisted symbiosis: how humans and nonhumans, whether wild and domesticated, are trapped by and dependent on *homo sapiens'* wish to display power and control. Jo-Anne demonstrates how our indifference and negligence, our awe and ridicule, and our compulsion to connect and to humiliate are different facets of that same urge.

* * *

What most impressed me about the photo in the Thai slaughterhouse was its variegated colors, the light splayed across the man's shoulders, the compositional balance of the men arrayed around the animal, the pigs seen behind the man with the knife and the bowl. All these elements brought together the muscular tension and attention of the moment with the strange passivity, even incurious absence of feeling, that permeates the image.

For me, many of Jo-Anne's photos reflect what W. B. Yeats may have called a "terrible beauty." Amid the mud and offal, body parts and ordure, Jo-Anne's "moments" draw your eye to the glistening skins, the shimmering fur, the iridescent feathers, or the unblinking gaze of the animals themselves. Beauty lies, as in this photo, in the rich tints; or it emerges from the chiaroscuro of the darkened chicken sheds or the minks' cages in twilight. You can discover it in the patterns of rabbits' blood on the slaughterhouse floor or in the glinting afterbirth on a veal calf's snout. You can locate it in our frantic efforts to make contact: a child's hand reaching out to a bear's paw; a baby chimp clasping an adult human; the sharp splash of sanguinary red next to a dead sheep among a flock awaiting transportation. It's even there when no animal is present: relief and memories of loss recalled by a stereotaxic chair in an abandoned vivisection facility; the elegant curves of hooks without corpses, strung like shower-curtain rings from a beam; the clusters of proud, blood-stained human handprints plastered on the wall next to where rattlesnakes' skins hang.

That eruption of beauty out of horror highlights the challenges facing those of us who care deeply about the lives and deaths of other animals and attempt to communicate in ways that will make people stop and think about their

choices. The limitations of the frame—what's left in; what's kept out—further problematize depictions of suffering: When does looking become complicity? When does beauty condense the horror or dilute it? When does holding up a mirror to nature shade into mere self-reflection? For me, as a versifier, the same may be said of words: when does the classical mandate of *ut pictura poesis* ("as is painting, so is poetry") become technical bravado, unwon sentimentality, or the overly polished veneer of unearned indignation? These open and perhaps unanswerable questions inevitably point to the choice of meter for "The Animals Are Leaving Us."

* * *

Jo-Anne's photograph arrived in my inbox as I was thinking about what to write for a satirical verse epic I was composing. *The Trumpiad* began after the November 2016 U.S. election as an attempt to interrogate my beliefs about my adopted country and figure out what a sizeable minority of the electorate had signaled in choosing the forty-fifth president as their commander in chief. Each month, I charted the vagaries, scandals, and cultural touchstones of the administration, as well as the broader issues of climate change, economic disparities, and democracy in the Anthropocene. (You can read the work at martin-rowe.com.)

I'd chosen for my epic the rhyme pattern that Lord Byron used for his masterpiece *Don Juan*. Ottava rima (abababcc) had had a venerable history in mock-heroic epics before Byron began his work in 1818: Boccaccio, Tasso, and Ariosto had written in it centuries before. Archaic though it was, ottava rima seemed appropriate. It retained the pithy or subversive conclusiveness of the couplet, and expanded the ballad-like quatrain to supply that final couplet with more heft. The eight-line, multiple-stanza structure allowed conversational and even vulgar language to sit in tension with high-flown rhetoric and the steady beat of the iambic pentameter. And so most of "The Animals Are Leaving Us" became June 2019 of *The Trumpiad: Book the Third*.

In choosing this verse form, I sought to color my analysis of Jo-Anne's work with the narrative melancholy of the ballad and the satirical sharpness and moral outrage of the couplet. I wanted it to contain ottava rima's epic excessiveness: that there are almost *too many* ways we destroy the animals; that the animals *have* disappeared rather than *are* disappearing; and that their departure not only is because we've destroyed their habitat but also is a willed disappearance

born of their fear of, revulsion at, foresight regarding, or refusal to be a part of our climatic dance of death. An irony is that we destroy animals' habitat—one reason why they're leaving us—so that we can breed billions of members of a handful of select species (disappearing them into sheds around the world) . . . so that we make them leave us too.

As an epilogue to the poem "The Animals Are Leaving Us," I've included an "essay" I wrote for the international public-policy organization Brighter Green, in the spirit of the Irish satirist Jonathan Swift and in the context of 2020's pandemic. The novel coronavirus outbreak began (it is thought) as a zoonosis in a live animal market. When the slaughterhouses were briefly closed in the U.S. because workers were falling ill with COVID-19, the supply chain was interrupted, which led to infant animals being "culled" in vast numbers before they reached slaughter weight. This absurd, obscene, and wholly destructive "solution" seemed in every way to me then, as it does to me now, symptomatic of our utter failure as human beings to imagine our way out of destroying all life on this planet.

—February 2021

INTRODUCTION

Jo-Anne McArthur

Since I can remember, I've wanted to know what lay beneath, behind, beyond, and inside just about everything. I investigated, and then applied what was revealed to my worldview. There is no endpoint for curiosity, and from my journeys of discovery emerged stories and art. Photojournalism was, perhaps inevitably, a perfect vocation for me.

My work and mission are one and the same: to immerse myself in the experiences of others; to try to understand, and show something real. I get close—physically, emotionally, and intellectually—and in doing so I better understand the experience and the life of that "other." Over time, I've learned that all others are deserving of freedom from harm and should receive our support to pursue peaceful lives of their choosing. I know this because I wish these things for myself, as I am, like them, a complex, sentient being, with a desire for safety and joy.

The emphasis of an animal photojournalist is on *all* others. My circle of concern includes all sentient beings, not just those of greater status in a hierarchy that prioritizes their species' "charisma," our opinion of their species, and their use to us or to an ecosystem.

* * *

The origins of this book began with a photo I took of a pig in a slaughterhouse. The bodies of farmed pigs are genetically built for human consumption, but the animals' wild instincts aren't easily excised in the breeding process. Neither are their sensory capabilities. Scientists have discovered that a pig's sense of smell is two thousand times greater than ours, which means that she can locate a tasty truffle growing deep below the topsoil. Or rather, she could if she were allowed beyond the confinement of a crate—atop a concrete slab, inside a windowless room, within a hopeless building. Inside the slaughterhouse, the smells of excreta make *my* eyes water and *my* lungs burn. I can only imagine how the odor must assault a nose many orders of magnitude more sensitive than mine.

I have visited modern-day pig farms on four continents. I can see and imagine what it must be like for billions of pigs to live in cramped stalls, all of their senses deprived except for, cruelly, that sense of smell. I want to experience what it is like to be them, so that I can know. And I want others to know, which is why I go to these farms, as well as the slaughterhouses, research labs, zoos, aquaria, and all manner of places where we keep animals captive.

The more I learn about the capabilities, emotional depths, and desires of other animals, and the more I uncover how we deprive them of all these experiences—even the most basic—the less I accept the blindfold we collectively wear to shield ourselves from what we do to our fellow creatures. So I return, over and over, to bear witness to how others live at our hands.

Packing my cameras. Traveling. Going to the place. This is my act of seeking.

Opening a door. Taking my camera from its bag. Lifting the viewfinder to my eye. This is my act of seeing.

Capturing stories. That is to say, documenting the experiences of living and dying—real-life, immediate, and urgent. Leaving with these (often harrowing) moments safely tucked away in those cameras, which are my tools for acquiring and disseminating knowledge, and creating change. This is my act of hope.

Sharing images freely. Publishing stories widely. This is my catharsis.

* * *

I am often asked, "Whom do you want to see these images? Whom do you want to influence?" The answer is simple. It's you. It's you whom I want to join me on these journeys of discovery. It's with you that I want to sit before these images, flinching, perhaps, but wordlessly returning to look again. It's you whom I want to say, "Oh." "*Oh.*" And "I see."

These images are our starting point. This is our beginning.

THE ANIMALS ARE LEAVING US

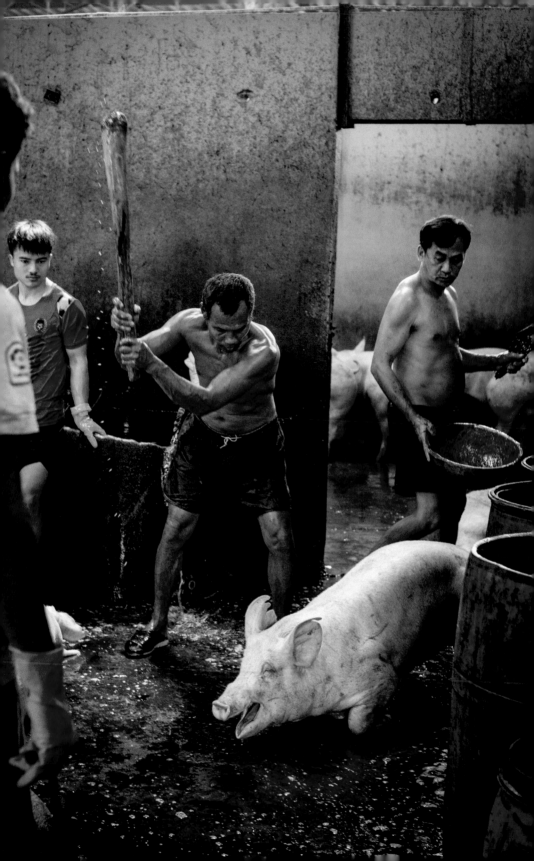

I

A man raises a club above his head,
 Gripped like a baseball bat before the thwack:
His muscles taut, the weight and light are spread
 Across his shoulder blades and down his back.
Three other men, one of them wearing red,
 Await the mortal, unconditional crack
Upon the bony temples of a boar
Sprawled on all fours upon the slickened floor.

II

The soccer shirts worn by the two young men
 Hint that a subtler game is found elsewhere.
It's true the pigskins sprawled within the pen
 Are also easily kicked. Perhaps both share
A wish to find a field. But they, again,
 Discover they are trapped in a nightmare
That only lets them briefly dream of pleasure,
Before they mark the beat of the last measure.

III

The ocher, russet, brown, orange, and peach,
 Contrasted with the teal, blue, black, and grey,
Evoke the autumnal colors of a beech
 Against a painted barn, the soft decay
Of leaves upon the soil, with hope that each
 Will be replaced with life another day
When spring returns. This fall displays a fall
That won't see one life be reborn at all.

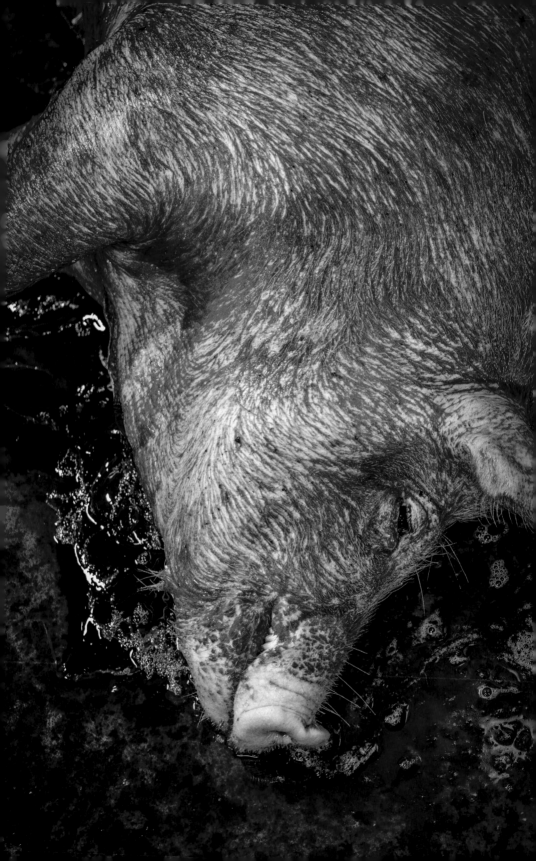

IV

An older man is naked to the waist;
 His flaccid arms and belly hang in space;
The biceps sag (for age won't be erased).
 His nipples droop; beard stubble lines his face.
He seems a man who's no longer in haste
 To force what will inevitably take place.
He's on the brink of leaving it behind.
His only contact with *this?* Bacon rind.

V

This man clutches a crimson metal bowl;
 The knife in his left hand expects its turn.
The humans are impassive, for the goal
 Of sanctioned executioners is to spurn
Emotion lest it flood the withered soul.
 No matter if the stomach starts to churn:
The greasy bludgeon, wet with soap and brine,
Must come down hard upon resisting swine.

VI

The pig opens his mouth and starts to scream;
 The notched ears twitch; the eyes close up in pain.
Beneath his torso froths a bloody stream
 From which he tries to scramble up: the stain
And scars upon his flank; the wrinkled seam
 Of hocks as hooves slip on the concrete drain.
And through the doorway, glimpses of the rest,
Who of their lives will soon be dispossessed.

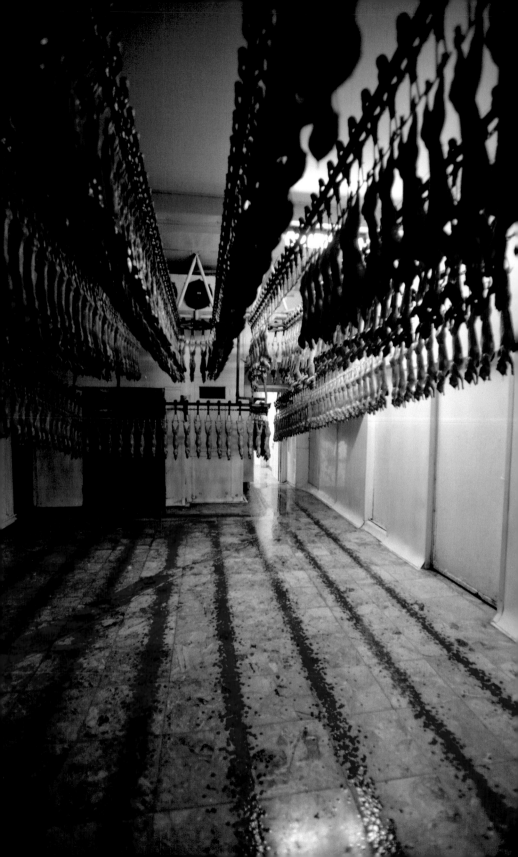

VII

This animal, like millions done to death
 In abattoirs and shambles round the globe,
Is one whose parting, terminated breath
 Follows a blow across the frontal lobe,
And then the cut. Of course, the shibboleth
 For "happy meat" eater or xenophobe
Is Western stun-and-bolt guns will allay
Their agony: their ending—"one bad day."

VIII

Yet is not this dispatch more honest, truer
 About what we believe or think is right?
Are not we each a dulled, indifferent viewer
 To violence that happens in our sight?
Don't we imagine we're not the wrongdoer
 When we let someone else put out the light?
For when has mercy ever counterweighted
The pounds of flesh that leave us satiated?

IX

The barrels fill with offal everywhere;
 The smells and stains seep into every skin.
The piss and shit are something that we share
 Whether we're blessed, luckless, or drenched in sin.
Confronted with mortality, we scare
 As much as those we deem supper or kin.
For in the end, when this short course is run,
We are alone; we will die one by one.

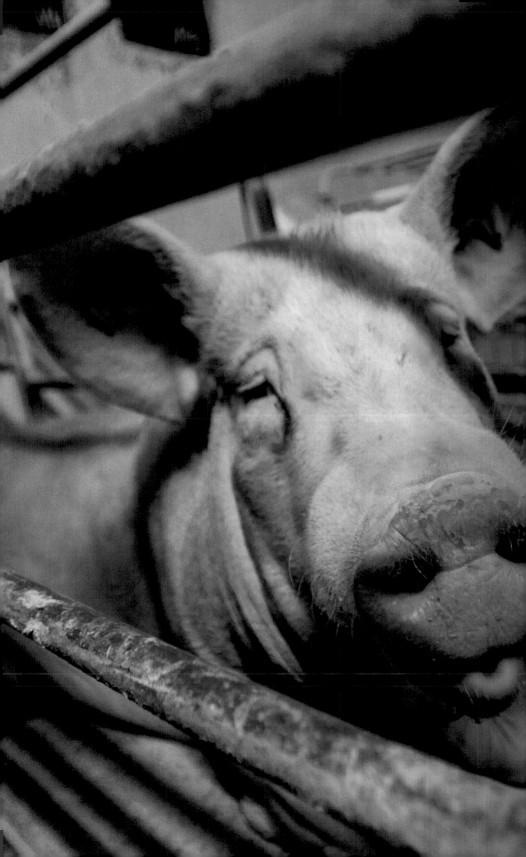

X

The sow sits on the stone-and-metal grate;
 She's barely old enough to birth her young.
Her world was, is, and will be this (a state
 Of absolute confinement). One among
Millions of others just like her await
 Each litter stolen, until she is swung
By shackled legs, stunned, and her throat is slit:
Only her passing puts a stop to it.

XI

How is it better that this sentient being
 Is trapped within a filthy, barren cage,
Her babies taken from her? Is *not* seeing
 Her brutal (non)existence how we assuage
The guilt that gnaws at us? How very freeing
 It is in a postmodern carnist age
To trust that industry and laws will keep
Us from the facts, ensure a good night's sleep!

XII

And so, conveniently, conveyer belt,
 Electric prod, hoist, knockbox, scalding tank;
The depilators, strippers of each pelt;
 And those who scythe each breast, back, rump, and shank,
And toss the innards of each beast who knelt
 And begged for mercy—these we have to thank
For letting us bow heads and carve a slice,
In honor of God and their "sacrifice."

* XI.6: **Carnist.** A term coined by psychologist Melanie Joy that she defines as "the invisible belief system, or ideology, that conditions people to eat certain animals" (see beyondcarnism.org).

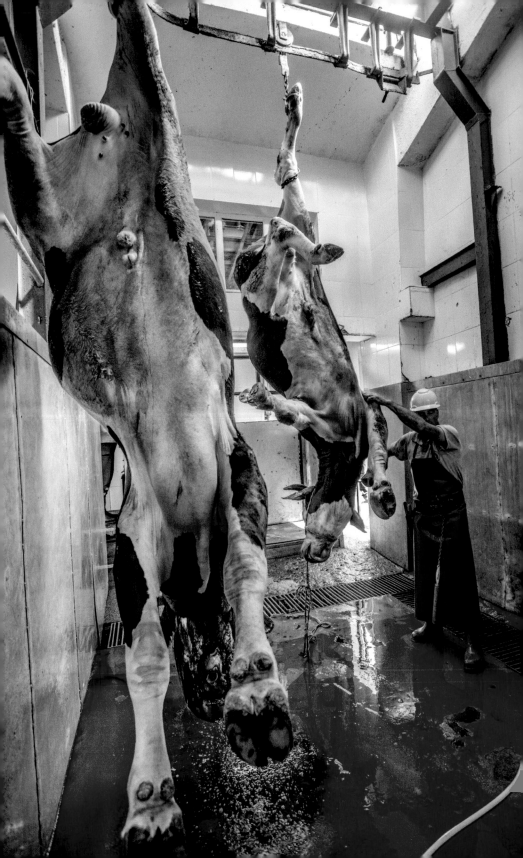

XIII

Each minute, tens of thousands are suspended,
　　Their bodies disassembled at kill stations.
Each minute, brief existences are ended
　　In unremitting mass eviscerations.
Each minute, human conscience is defended
　　By too-convenient self-justifications
That, as we have the gift of personhood,
All that we do to them is rendered good.

XIV

This slaughter is not natural selection;
　　These deaths are neither hallowed nor inspired.
Their shabby commonness is a deflection,
　　A numbing palliation of the acquired
Palate for dead meat that a broad cross-section
　　Of *normal* folk respect. Only we tired
And irritating vegans break the peace
In calling for the awfulness to cease.

XV

Much worse for me are those who dare to claim
　　How much they love the animals they harm;
How deeply they respect them; how they name
　　Each one of them, and try not to alarm
Them as they load them onto trucks. No blame
　　Should *ever* be leveled at how they farm.
They brought them into life to celebrate it;
And they have every right to terminate it.

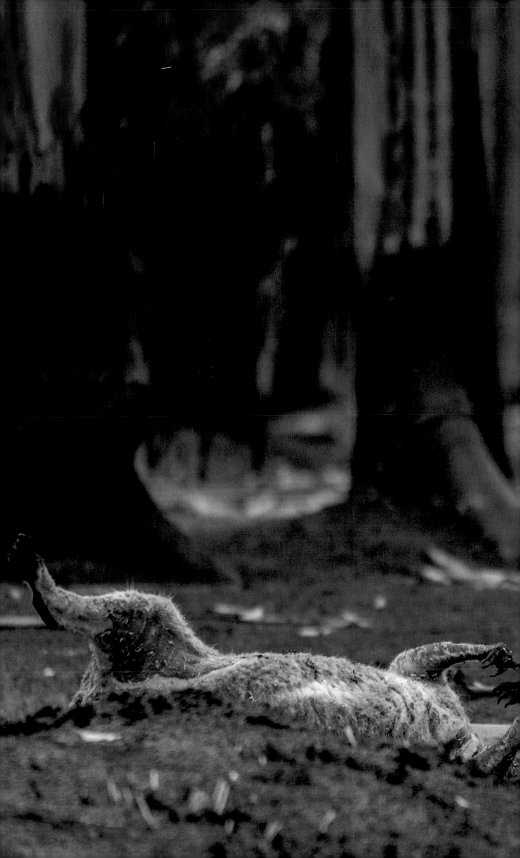

XVI

Or those who sigh the planet must be fed,
 That nature's cruel, or to each his own,
And other bunkum—as if the massed dead
 Weren't eating up the grain or soy that's grown,
Producing waste that fouls the watershed,
 Releasing odors and emissions. Moan
All you may want about agro-ecology,
But don't deny you owe them an apology.

XVII

We made this sordid, excremental vision;
 We chose these horrors, prearranged the pyre:
Each killing a deliberate decision,
 Another body added to the fire;
Each second a precisely willed elision,
 Another carcass tossed into the fryer.
And thus we pass the decades on this earth;
And thus we quantify material worth.

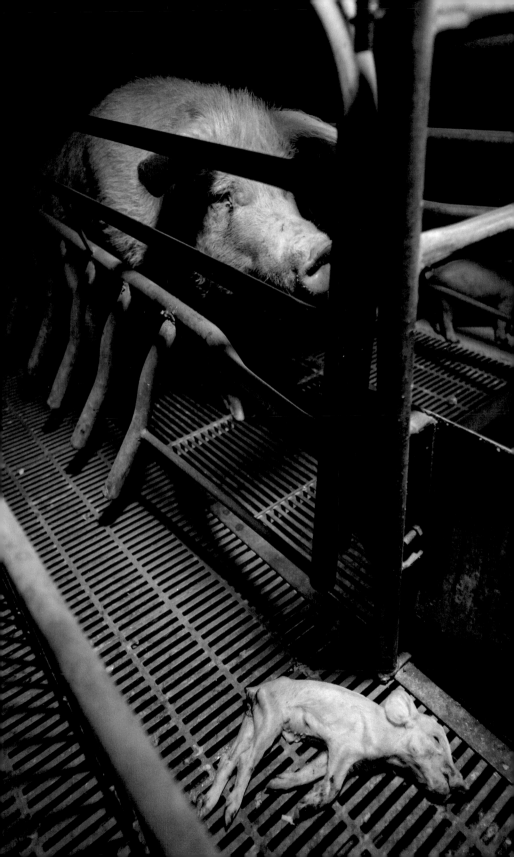

XVIII

Whom does she see in front of her, this sow,
 Who's birthed and lost so many in her crate?
A runt? A unit? Could we not allow
 That in her shadowed eyes we see the weight
Of hopelessness? And cannot we endow
 Her son or daughter's death upon a grate
With half a thought, before we stab the fork
Into the dinner all are killed for—pork?

XIX

The endless rounds of enforced impregnation,
 The piglets gone before they have been weaned;
Loss upon loss, a world of deprivation,
 A life unlived, her motherhood demeaned.
No one to touch her but for violation;
 "Biosecured," "harvested," "quarantined":
The object of contempt and persecution.
But which of us should plea for absolution?

XX

Is it too much to ask of us a pause,
 A pennyworth of straightforward humanity?
Yes, we may not have broken any laws,
 But are we not compounding a profanity,
A crime against a principle, first cause,
 Or golden rule? Or does our species' vanity
Compel us to reflect naked desire
That warrants no excuse or qualifier?

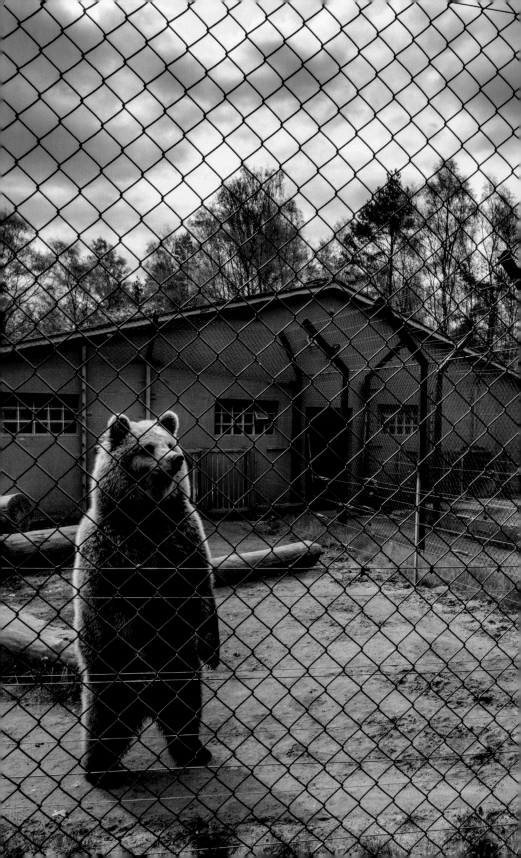

XXI

The animals are leaving us. Their traces
 Are disappearing from each mountain pass.
The species are deserting empty spaces,
 And no more trails wend through the prairie grass.
No salmon follow scents back to the places
 Where they were spawned, nor does a swirling mass
Of birds collect in autumn to fly forth;
And in the spring, not one will journey north.

XXII

The animals are leaving us. Their eyes
 No longer narrow in the underbrush.
The evenings are silent; when the skies
 Lighten, no songs or chirrups break the hush.
The anthills are abandoned, butterflies
 Fail to pupate, and pollen's fragrant blush
Will not coat any bees nor feed a hive:
There are not any more of them alive.

XXIII

The animals are leaving us. They've known
 For centuries the outlines of their fate
At our rough hands. They've mourned the whitened bone,
 Caressed the wounded skin, taken the bait
And gnawed their limbs off to escape. Each lone
 Zoo animal has paced their tiny crate
And hoped for that day when the way was clear
To leave the stares behind and disappear.

XXIV

The animals are leaving us. They've seen
 What will come to us all—and very soon.
They've felt the ice melt under them, the green
 Savanna turn to ash, and blue lagoon
Clog with effluent, plastic, or benzene.
 They've sensed the oceans change. The beaches strewn
With garbage, where once they prepared a nest,
Became the graveyards where they lie at rest.

XXV

The animals are leaving us—departed
 Before we even knew that they existed:
The organisms whom we hadn't charted,
 Whose fate we did not know, yet who'd persisted
Through age upon age—who'd swum, slunk, crept, darted,
 Burrowed, or floated on the air, unlisted.
Why would one choose human signification
When one would face instant annihilation?

XXVI

The animals are leaving us. They've read
 The writing on the wall. The gristly meat
That rots in chomping jaws; the vein that's bled
 So liberally; the license to mistreat;
The trophies stuffed and mounted, head by head;
 The babies ripped from mom's lactating teat—
They've understood too well what will await them.
They recognize how vehemently we hate them.

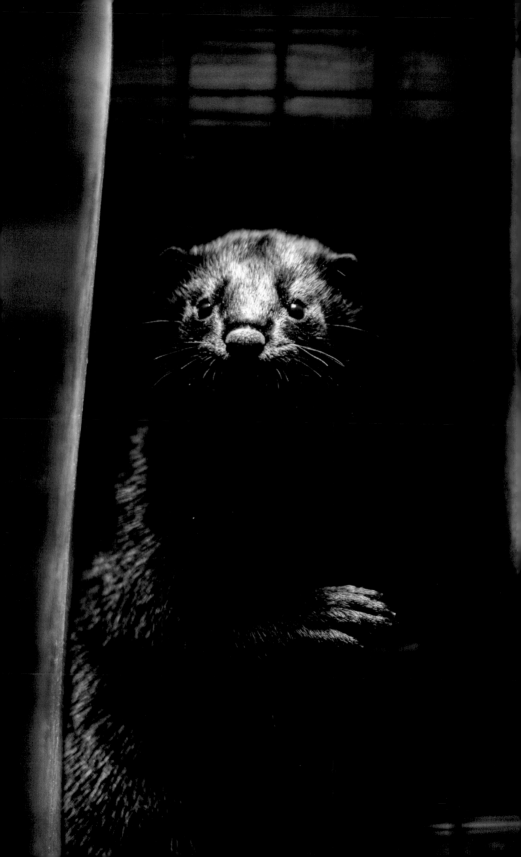

XXVII

And so they're leaving us. The soundless seas
 Will soon contain no fish, while the crustaceans,
Shell-less, will die off too. No winter freeze
 Will shape the icecaps, and the island nations
Will sink into the depths. Boreal trees
 Will desiccate and burn, while fluctuations
In temperatures will increase till the heat
Will lead to people dying on the street.

XXVIII

And so they're leaving us. Why stick around
 To feel our fury's enervated gasp?
Why stay to watch who's saved and who is drowned,
 Whose fingers let slip an enfeebled grasp?
Why gloat when bloated bodies form the ground
 Upon which other humans stand—to rasp
Their own last lungful? Why stay and exalt?
When all are gone, then there's no one to fault.

XXIX

And so they're leaving us to walk unheard
 Through cinders, cracked beds, each forsaken city,
Reciting how such human-ness conferred
 A special suffering, a unique pity;
How, as in the beginning with the Word,
 So at the end the epitaphs are witty.
But at what moment will we realize
No one is left to admire *this* demise?

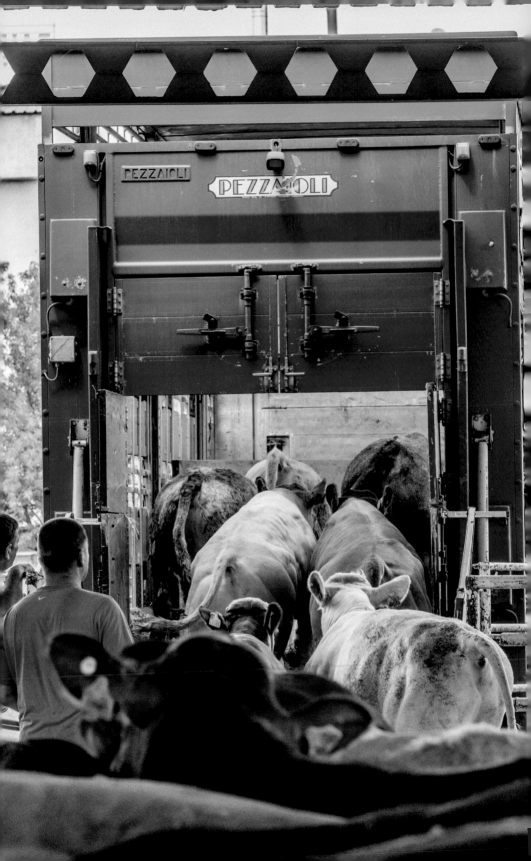

XXX

No one to soothe the loss, or justify us.
 No "other" who can tell us who we are.
No one who can with tenderness supply us;
 No gentler kin or kind than us by far.
No one who hasn't been extinguished by us
 On this late planet, third closest its star.
No creature who stirs the imagination;
No one to mourn us after the cremation.

XXXI

No one to illustrate our children's stories,
 No one to stir our wonder or our awe;
No one to shape our myths or allegories,
 No one upon whose love the loveless draw;
No one to reference from the observatories:
 The serpent, horse, bear, eagle. Tooth and claw,
And bone and skull—compacted into clay:
Another great extinction underway.

XXXII

And so they're leaving us, and as they go
 Earth shrivels likewise. All of God's creation
At once so good and rare, under the glow
 Of ever-greater warmth: an aberration
Within vast, empty space and time—a throw
 Of dice, but now game over . . . and cessation.
Two hundred thousand years our total span:
The birth, the flourishing, the death of Man.

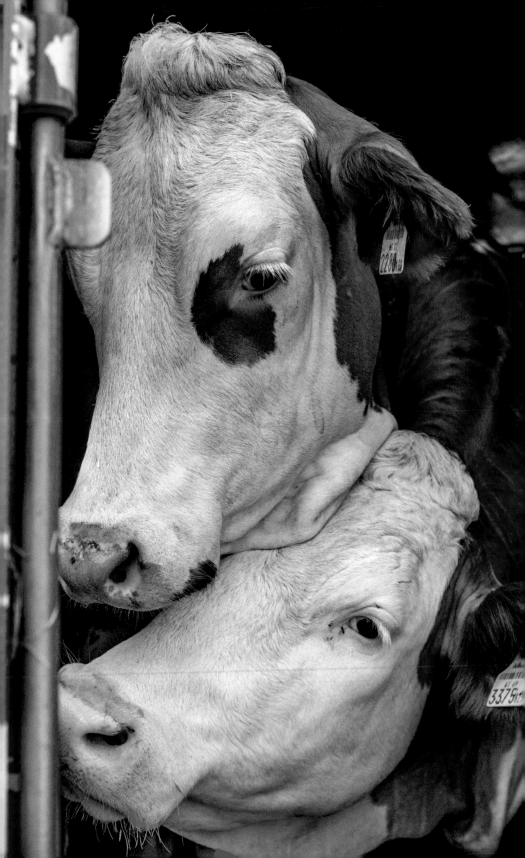

XXXIII

Another pig is brought onto the floor,
 Shrieks pouring from her mouth. Her ululation—
Frantic, despairing, unanswered: "What for?"
 She cries, "What crime? What is the allegation
That's brought me to this place? When did the war
 Begin against us? And what provocation
Did I stir up that you should thus betray me,
Beat me into unconsciousness, and slay me?

XXXIV

"Why persecute us? How have we offended
 That you should handle us with such disdain?
We could have just as easily befriended
 Each other, helped each other meet the strain
Of aging. We, together, could have ended
 The dissonance that occupies your brain:
You tell yourselves that you're not cruel men,
Yet you love harming, again and again."

XXXV

Her lamentation stops: phlegm fills her throat;
 Her eyes roll up; her legs buckle and fold.
The club comes down once more. In the remote
 Recesses of our minds, where lies the old
Fiction that we are good, might we devote
 A passing thought to she whose death, foretold,
Portends the passing of the oldest teachers,
And us—the murderers of other creatures?

EPILOGUE

A Modest Proposal

Kill All the Animals: A Satire for the Time of COVID

Following news that the novel coronavirus may have had its origins in a civet cat or a pangolin or a bamboo rat or a bat or a raccoon dog or a snake, and in the wake of the outbreaks of African swine virus in China and avian flu in Germany and South Carolina—not to say MERS, SARS, Ebola, HIV, Green Monkey Disease, and so on—I have a simple solution: let's kill all the animals. No more zoonotic diseases; no more slaughterhouses, where workers come down with COVID-19, or wear diapers and suffer urinary tract infections because they're not allowed to leave the kill line. No more zoos having to feed one species to another because no one is visiting them anymore. No more animals wandering around our deserted streets, lording it over us in our confinement.

I've no doubt we've the skills to do it. For the last 70,000 years of our colonization of the planet, *homo sapiens* have caused mass extinctions wherever we've gone, and we're getting better at it, having cleansed the planet of 60 percent of its animal populations in only 50 years. We're hard at work: every day, someone is slitting, skinning, eviscerating, clubbing, beating, kicking, dragging, hoisting, shackling, or whipping some creature. And we've come up with so many ways to dispatch animals: shooting them with a rifle, bolt gun, or a bow and arrow; sticking colorful spears into them in an arena; or letting them fight one another to the death.

We're marvels of efficiency. We kill 70 billion farmed animals, and an untold number of fish, per annum. (We don't know how many individuals, because we measure fish by the ton.) And the U.S. is demonstrating particular excellence. In addition to the 10 billion farmed animals we send to slaughter each year, we get our government to kill millions of wild birds and mammals who have the temerity to impede our efforts to raise animals so we can kill them when we want to. The world's fishing industry is also incredibly resourceful. It handily gathers up tens of thousands of other marine creatures as "bycatch"—a fancy name for

cetaceans, sea turtles, and other animals who trap themselves in our nets. We kill them too.

We even kill animals before we intended to. Right now, farmers are "depopulating" tens of millions of piglets, chicks, and calves because the closing of some slaughterhouses due to COVID-19 has meant these animals wouldn't be the right size when they would have been brought to slaughter, a few weeks later. I know—what a bummer! However, we can rest assured that when COVID dies down, we'll get right back to raising them properly so we can kill them again.

Now, you may think it would be impossible to kill *all* the animals. But consider the evidence. We've reduced elephants and other species deemed "charismatic fauna" to levels where extinction is imminent; we've deposited plastic in all the world's ecosystems to poison the gullets and stomachs of millions of birds and fish; and we're on a thrilling trajectory to warm the planet so the ice floes won't support (literally) polar bears and seal pups, and the oceans will be so overheated and acidified that phytoplankton won't buttress the trophic cascade, the coral reefs will die, and the spawning grounds will collapse. On land, we're winning our fight against biodiversity by chopping down habitat for timber, mining, biofuels, cattle grazing, and feedstock; and we're plowing up hedgerows, filling in wetlands, and paving over every last slab of wildness as fast as we can. We're even decimating insects.

So, we're doing a heck of a job already. My concern is we might not take the final step. Sentimentalists among us may wish to keep the animals alive so we can sever their fins or rip their shells off to make soup; or lop off their penises, hack off their horns, or harvest their bile to keep us strong and healthy. Epicureans may wonder where pleasure would be found if we couldn't stick an electric prod up a fox's anus to wear their skin, force-feed geese for their livers, shoot stags, blast prairie dogs, or massacre lions on game farms so we could show animals who's boss. Anthropologists may fret that cultures dependent on stuffing as many hotdogs in our mouths as possible or carrying out our expiatory rituals on animals would wither and die. Pet owners may be concerned that if we killed all the other animals, there wouldn't be any animals to feed our pets. But don't worry. We can feed our pets to the tigers we breed in zoos, and then we can kill them too.

I understand. Planning that final step toward the extinction of animate life on this planet may seem daunting—even undesirable. For what are we as

human beings if we can't exact our every appetitive whim, superstition, craven desire, contempt, need for control, and fear on an animal other than us? But trust me: it's simpler this way—and may not be that hard. After all, if we just stay the course, then in, say, two hundred years' time, we might just accomplish our dream. Either that, or it won't matter anyway, because our own species won't be around to appreciate our handiwork.

ACKNOWLEDGMENTS

Jo-Anne McArthur

I would like to thank Martin Rowe for sharing his creative writing, and for conceiving this excerpt from *The Trumpiad* as its own book. I'm grateful to Christopher Shoebridge for his thoughtful design. To Martin and Chris both, your friendship and collaboration help me get way ahead of where I might otherwise be. To you who picked up this book, thank you. I hope it galvanizes your creative spirit to help others every day, and in any way that you can.

Martin Rowe

Much appreciation as always goes to Jo-Anne McArthur for being a continual source of inspiration to me, as she is to many others, in her courage and dedication and for her honest and compassionate gaze. I, too, would like to thank Christopher Shoebridge for his sensitive and imaginative design and layout of *The Animals Are Leaving Us*. I would like to thank my colleagues Brian Normoyle and Emily Lavieri-Scull for their support of this book, and Evander Lomke for his unerring interest in my verse. I would also like to thank Brighter Green for giving Lantern and me permission to reprint "Kill All the Animals." You can find the original at: https://medium.com/brighter-green/a-modest-proposal-kill-all-the-animals-faf5a1c4093c.

Finally, none of what I've managed to accomplish in the last thirty years would have been possible without two very important people in my life. The first is my partner, Mia MacDonald, who first alerted me to the horrors we inflict on other animals. The second is Gene Gollogly, my former colleague and mentor, who died as this book was in production. Thank you both for your generosity of spirit, your passion, and your companionship. You changed the course of my life for the very best.

THE PHOTOGRAPHS

Cover: A pig lying in water in a factory farm. Thailand, 2019.

Back Cover: A decapitated pig carcass hangs inside a slaughterhouse. Taiwan, 2019.

1. A pig being knocked down with a club before being killed at a slaughterhouse. Thailand, 2019.
2. One of hundreds of pigs bleeding out on a wet slaughterhouse floor. Thailand, 2019.
3. Hanging upside down from a conveyor, thousands of rabbit carcasses bleed out as they move slowly through a cooling room before being packed for market. Spain, 2013.
4. A sow looks out from a gestation crate at an industrial pig farm. Sweden, 2009.
5. At a slaughterhouse, bulls are hung by one leg and hoisted into the air before their necks are slit. Turkey, 2018.
6. The body of an eastern grey kangaroo lies in a eucalyptus plantation. The cataclysmic bush fires in Australia claimed the lives of an estimated three billion animals. Australia, 2020.
7. A sow in a gestation crate. Near her lies the body of one of her piglets. Spain, 2011.
8. A brown bear rhythmically circles his enclosure, stopping at this spot each time to look beyond the fence. Germany, 2016.
9. A view of an industrial pig farm from the outside, before investigators enter in the early hours of the morning. Italy, 2015.
10. A black mink looks out beyond her tiny cage at a fur farm. Canada, 2014.
11. After a brief rest at the Bulgarian–Turkish border, cattle are loaded back onto trucks for the final leg of their journey to slaughter. Turkey, 2018.
12. Two cows huddled together inside a transport truck at the Bulgarian–Turkish border. Turkey, 2018.

ABOUT THE AUTHORS

Photo: Jo-Anne McArthur

Martin Rowe is the author of *The Polar Bear in the Zoo: A Speculation* and *The Elephants in the Room: An Excavation* (both Lantern, 2013), and co-author of *Right Off the Bat: Baseball, Cricket, Literature, and Life* (with Evander Lomke, published by Paul Dry Books, 2013). He is also the author of a novel, *Nicaea: A Book of Correspondences* (Lindisfarne, 2003), and the co-founder of Lantern Publishing & Media. He lives in Brooklyn, New York. His website is martin-rowe.com.

Photo: Josée Van Wissen

Jo-Anne McArthur is an award-winning photographer, author, and sought-after speaker. Through her long-term body of work, *We Animals*, she has documented our complex relationship with animals around the globe. Since 1998, her work has taken her to over sixty countries. In 2019, she founded the photo agency We Animals Media. McArthur was the subject of the critically acclaimed 2013 film *The Ghosts in Our Machine*, which followed her as she documented the plight of abused and exploited animals and advocated for their rights as sentient beings. Her website is WeAnimalsMedia.org.

ABOUT THE PUBLISHER

LANTERN PUBLISHING & MEDIA is a non-profit publishing company founded in 2020 to follow and expand on the legacy of Lantern Books—a publishing company started in 1999 on the principles of living with a greater depth and commitment to the preservation of the natural world. Like its predecessor, Lantern Publishing & Media produces books on animal advocacy, veganism, religion, family therapy, environmentalism, and social justice. In addition, Lantern Publishing & Media publishes works in humane education.

Lantern is dedicated to printing in the United States on recycled paper and saving resources in our day-to-day operations. Our titles are also available as e-books and audiobooks. To catch up on Lantern's publishing program, visit us at www.lanternpm.org. You can find us on social media at @lanternpm.

lanternpm.org